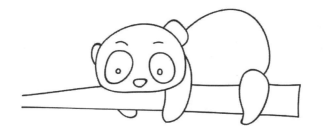

THE STEP-BY-STEP
DRAWING BOOK

FOR KIDS

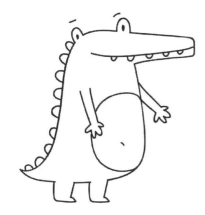

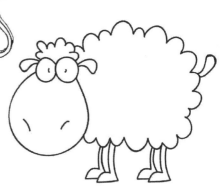

THIS WONDERFUL BOOK BELONGS TO:

PEANUT PRODIGY

THINK YOU HAVE WHAT IT TAKES TO WIN OUR DRAWING CONTEST ?

We want you to draw your favorite picture from the book and send it into our Young Artists Drawing!

Please have your parents email us your illustration and we will select an entry to win our fully equipt art case every other month!

Email us your picture to:

 peanutprodigypublishing@gmail.com

If you enjoyed this book as much as we do, please also leave us a review on Amazon. Your support is what keeps us going!

Happy Drawing!

−Peanut Prodigy Team

P.S. Even if you don't win, your entry will be put into a random drawing for a $50 Amazon Gift Card

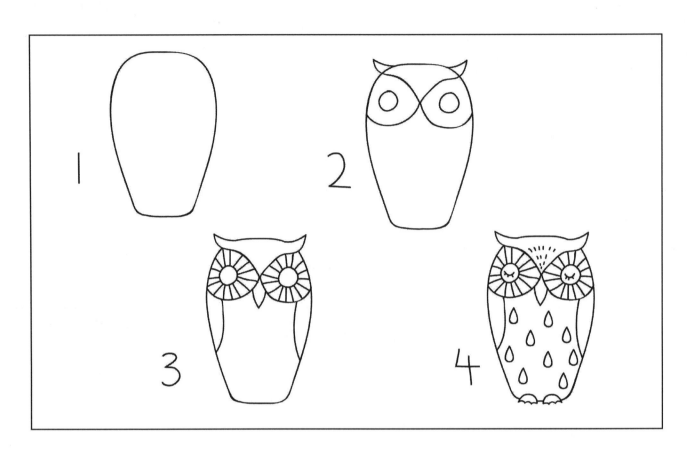

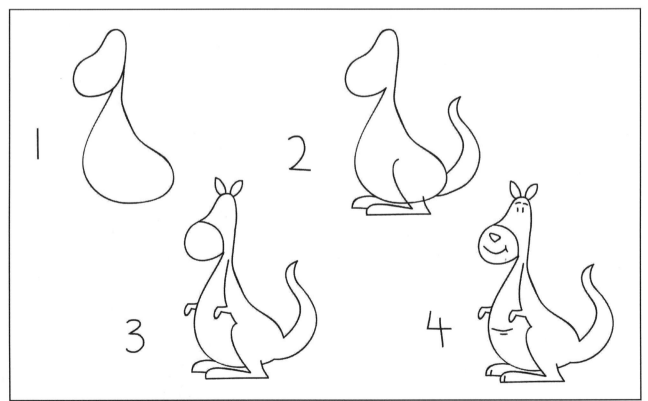

YOUR TURN !!

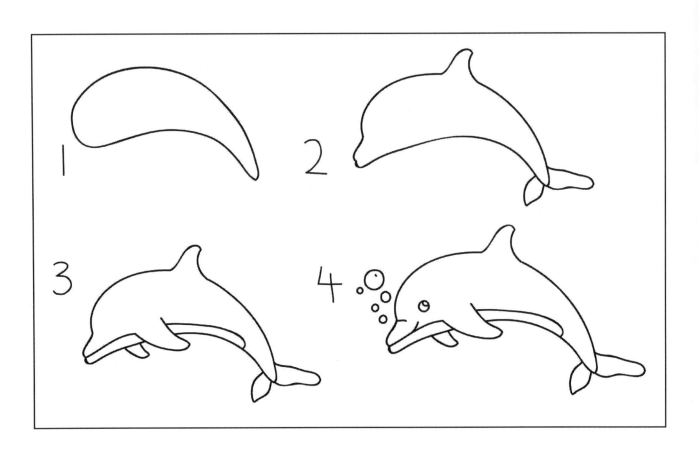

1

2

3

4

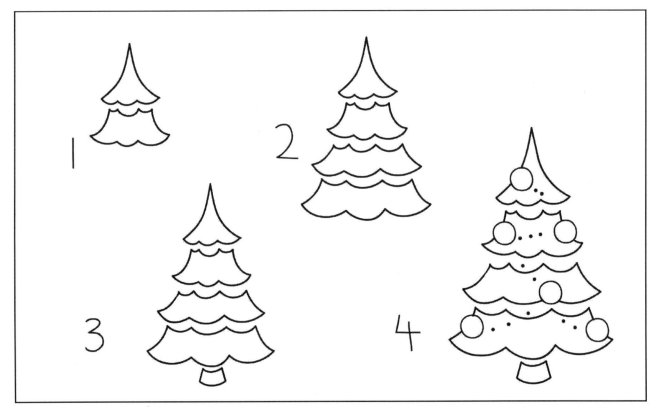

1

2

3

4

YOUR TURN !!

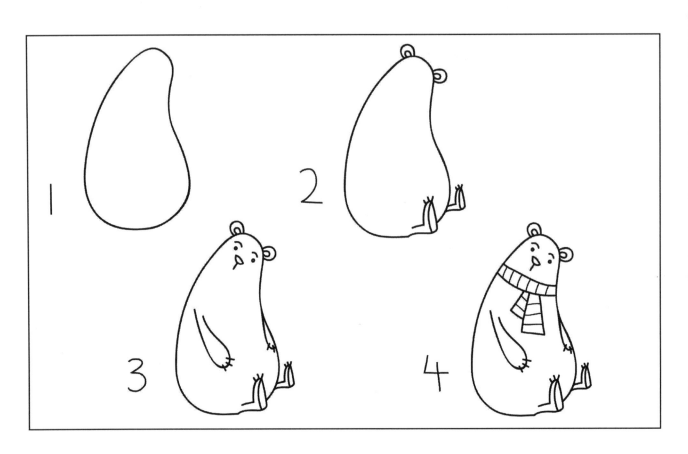

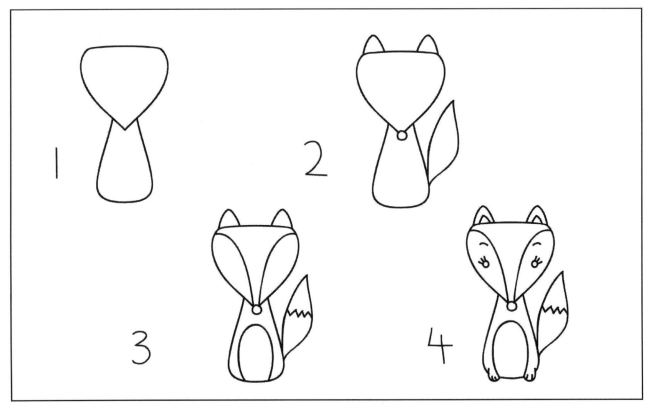

YOUR TURN !!

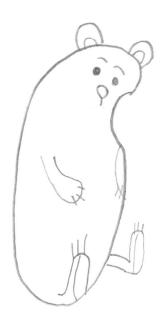

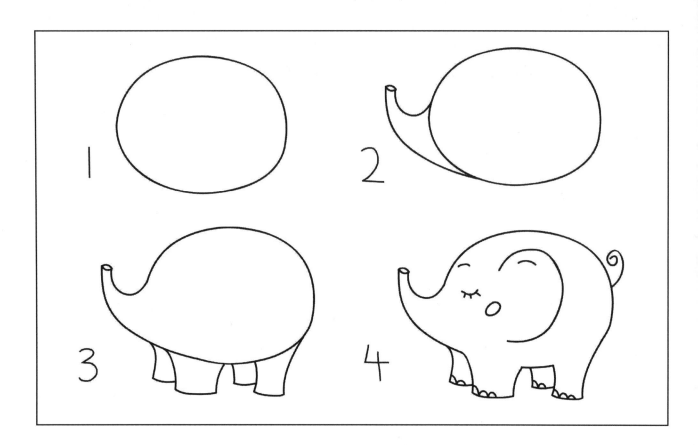

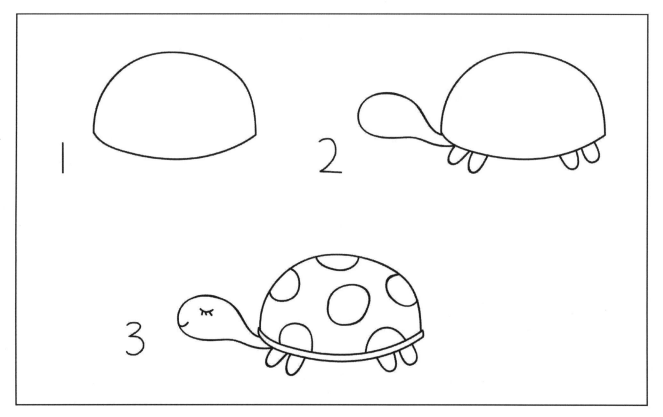

YOUR TURN !!

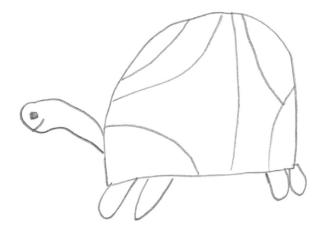

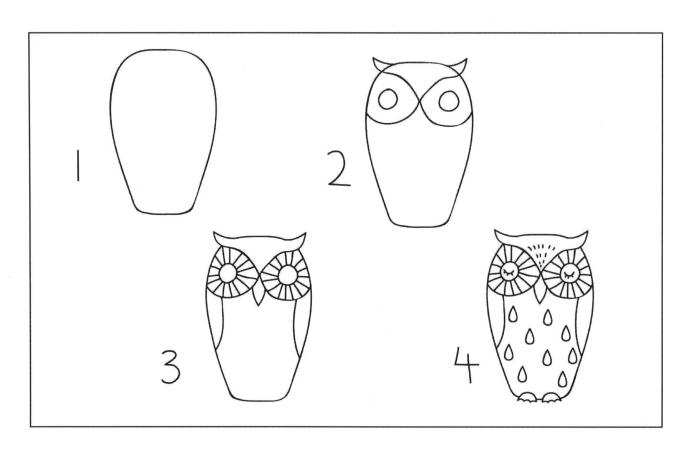

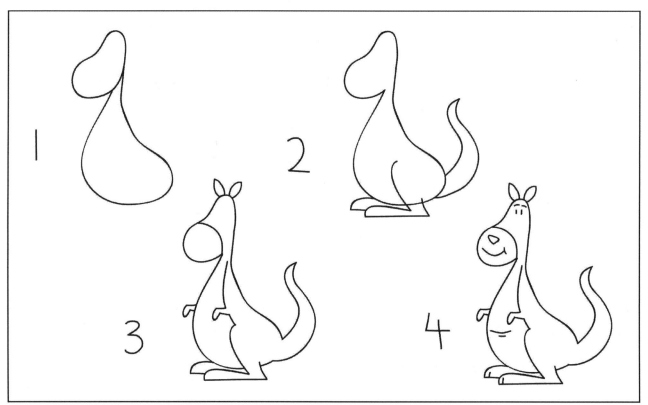

YOUR TURN !!

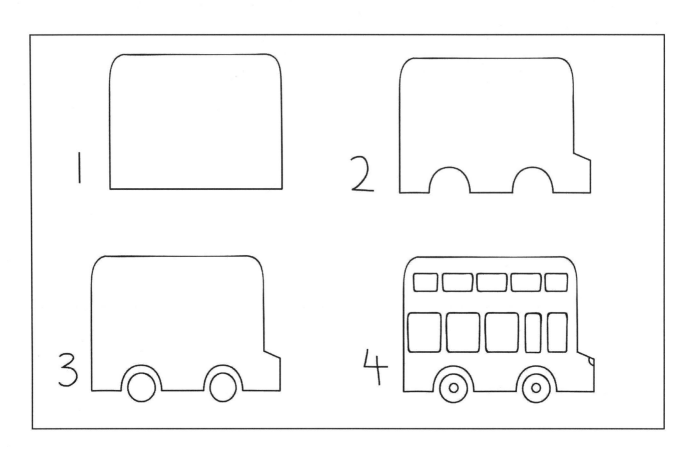

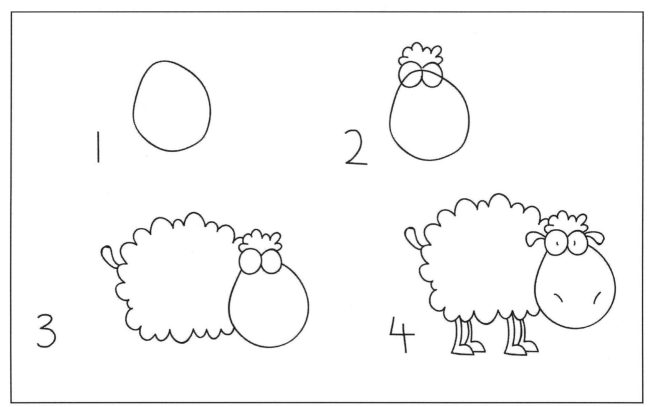

YOUR TURN !!

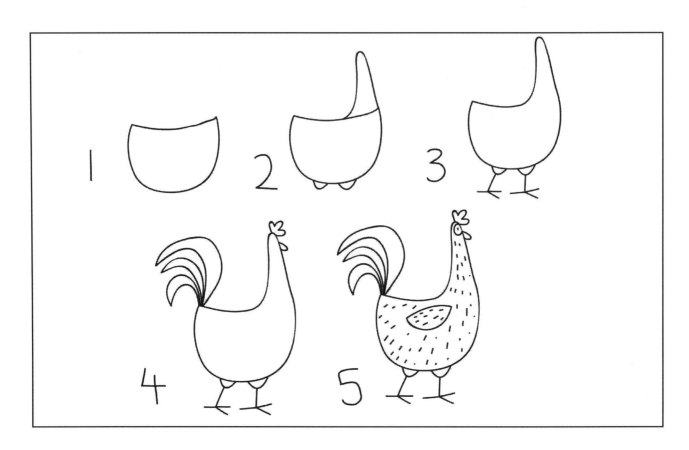

1

2

3

4

5

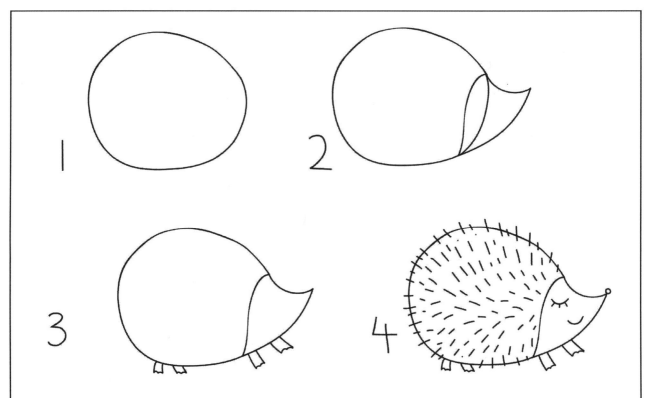

1

2

3

4

YOUR TURN !!

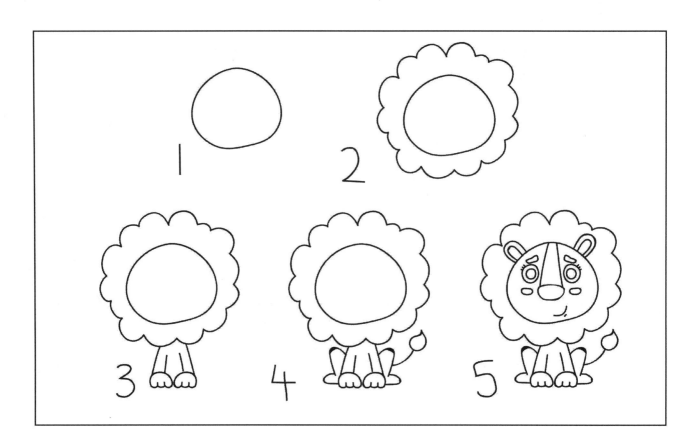

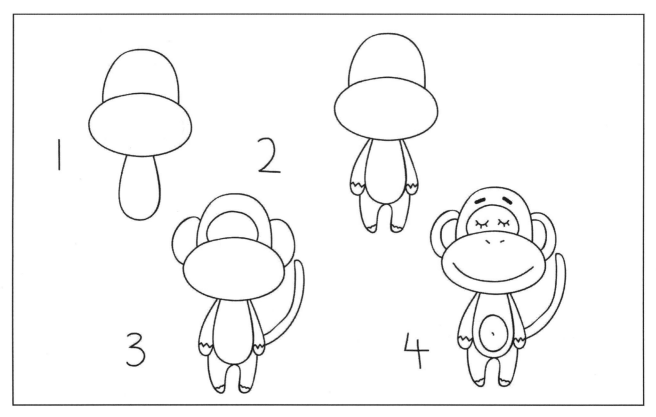

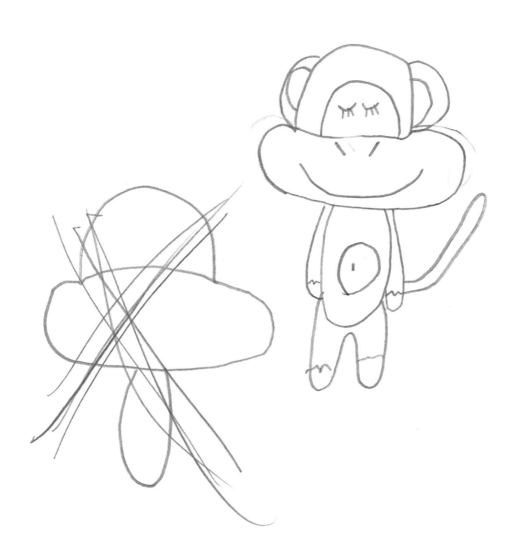

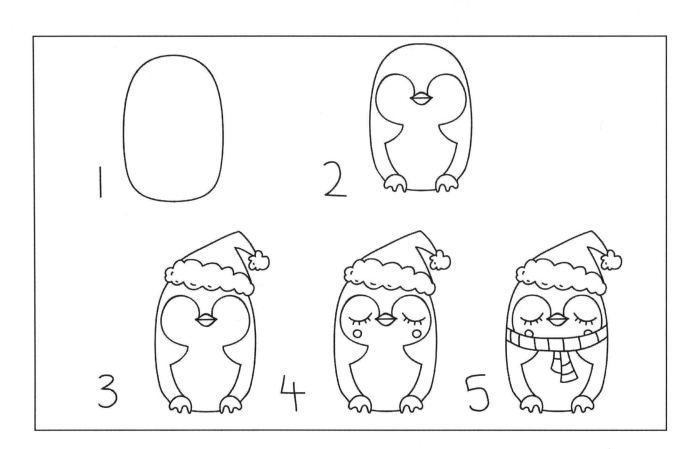

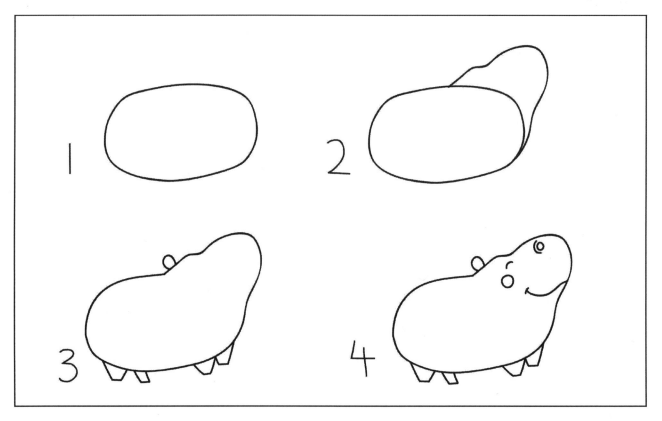

YOUR TURN !!

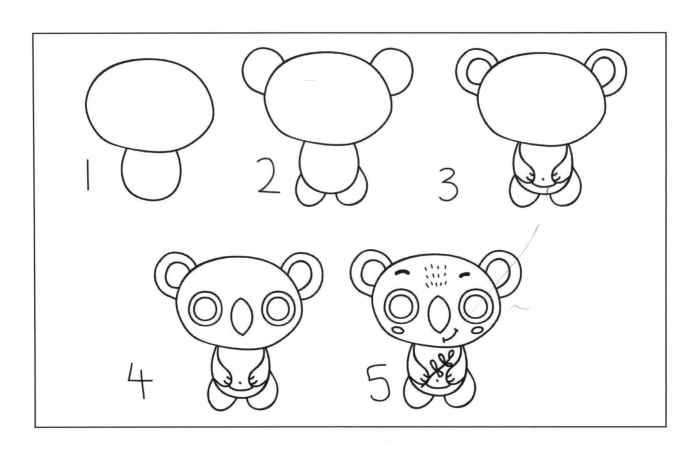

1　　2　　3

4　　5

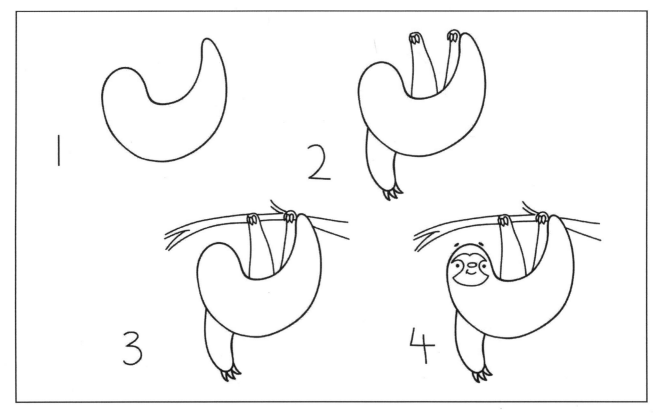

1　　2

3　　4

YOUR TURN !!

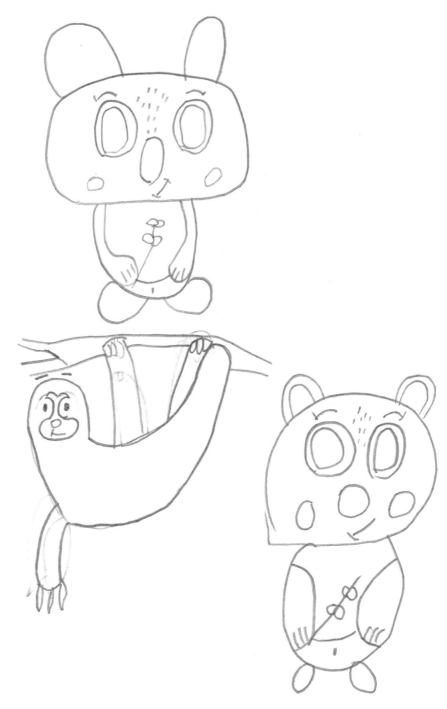

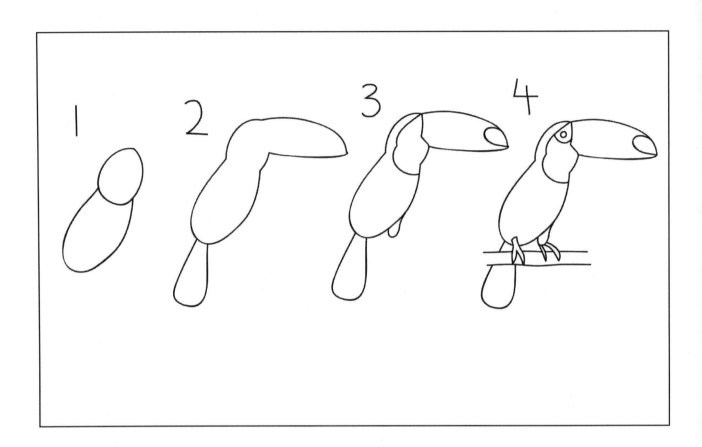

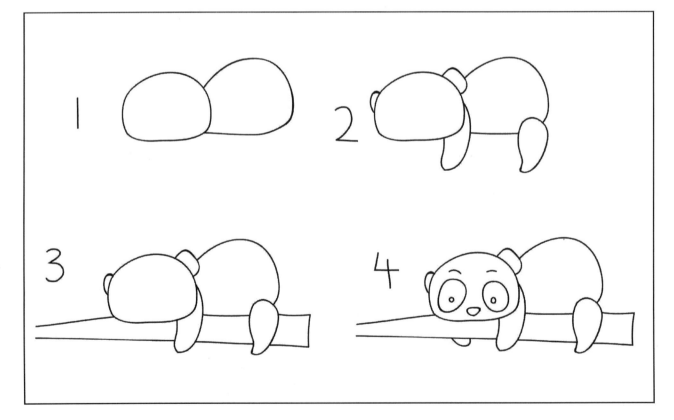

YOUR TURN !!

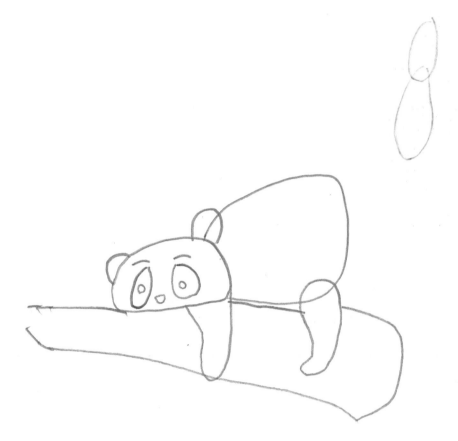

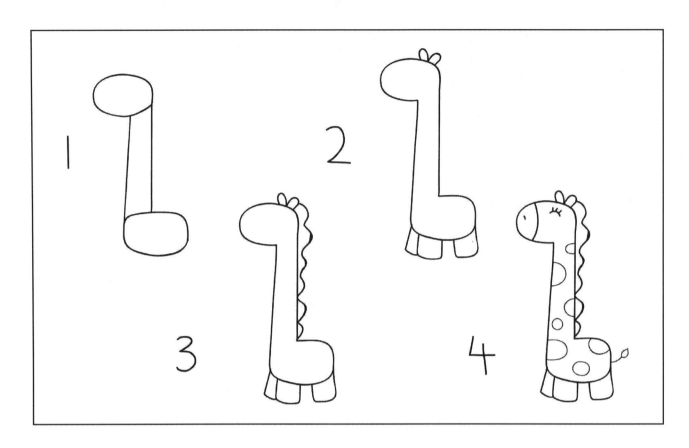

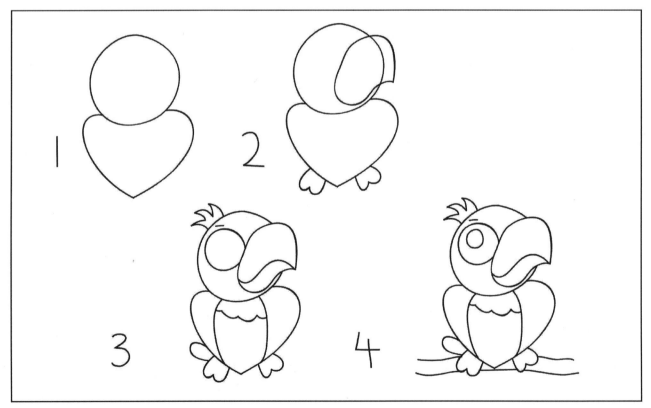

YOUR TURN !!

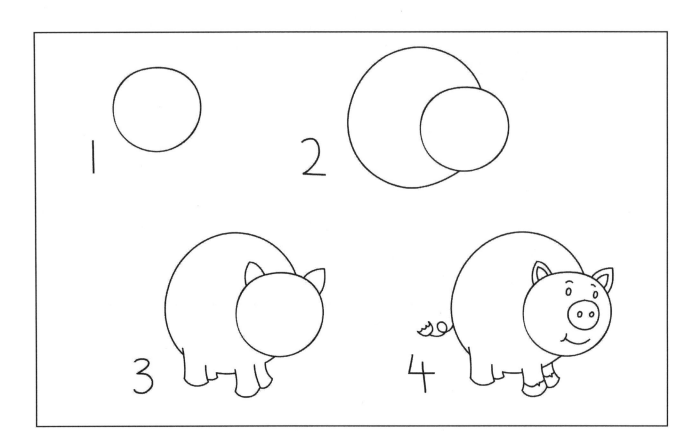

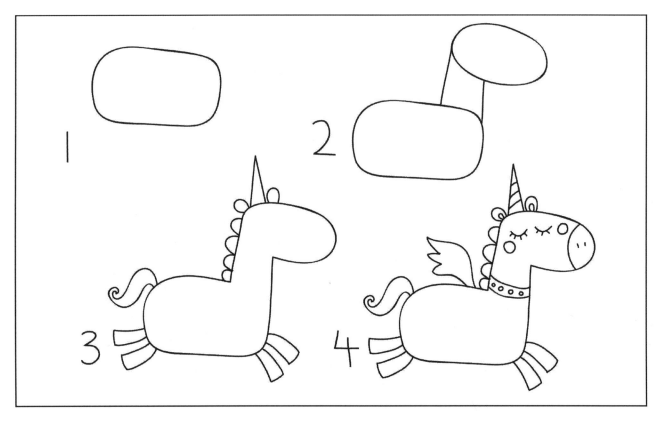

YOUR TURN !!

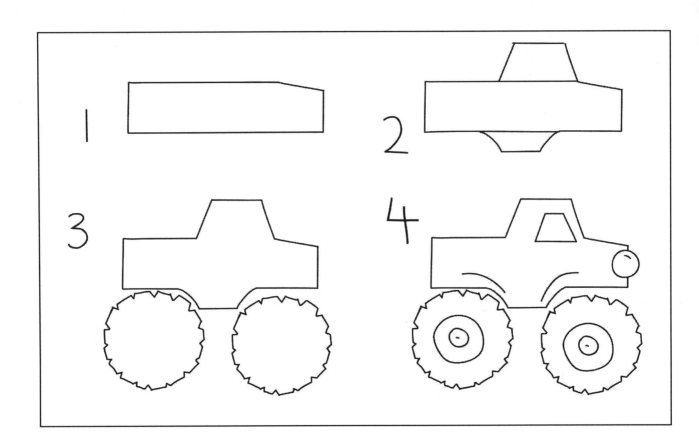

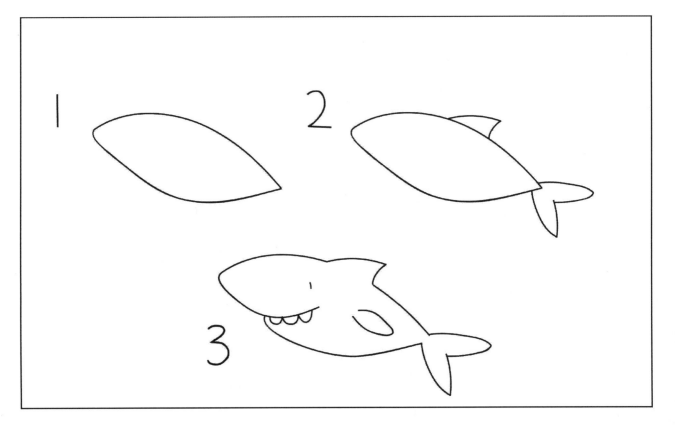

YOUR TURN !!

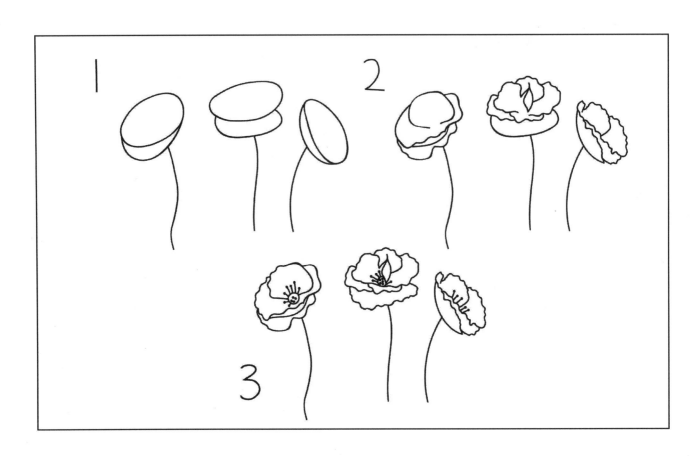

1 2

3

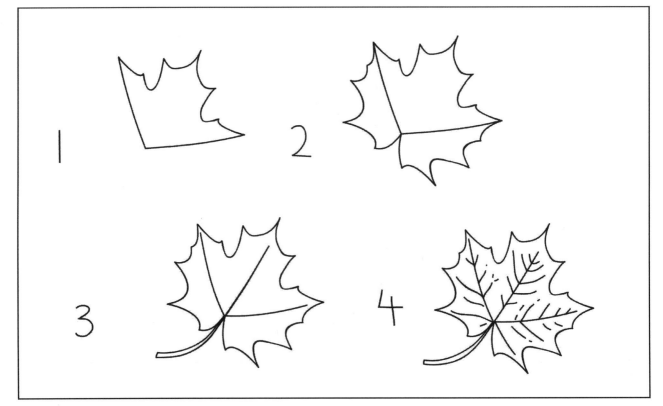

1 2

3 4

YOUR TURN !!

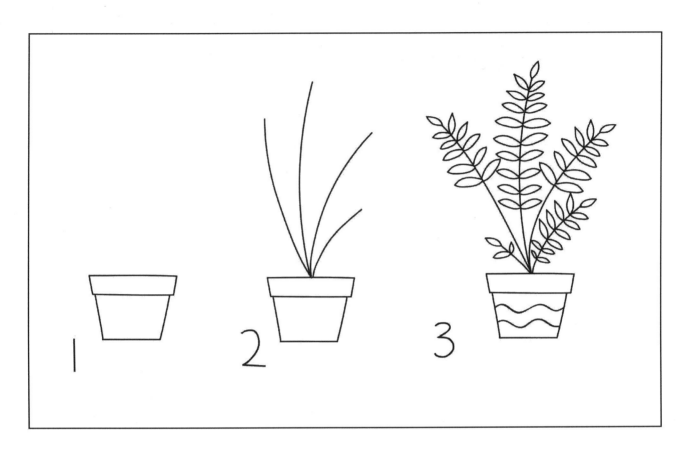

1 2 3

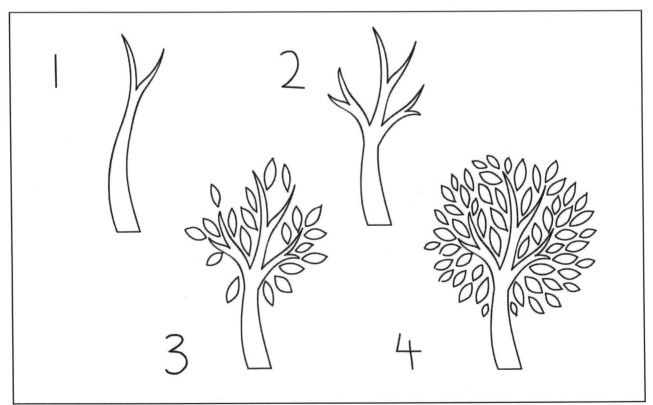

1 2

3 4

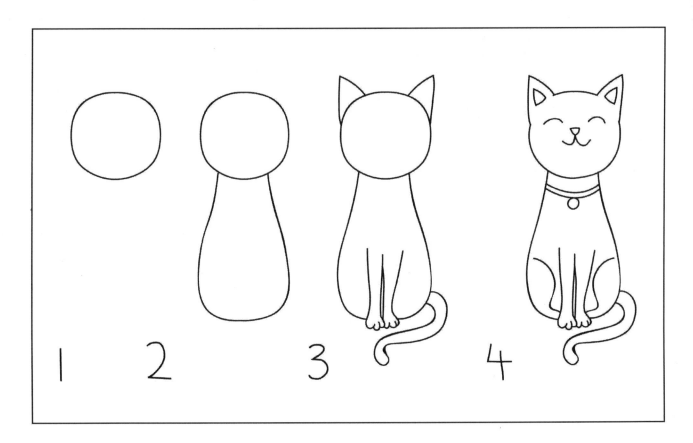

1 2 3 4

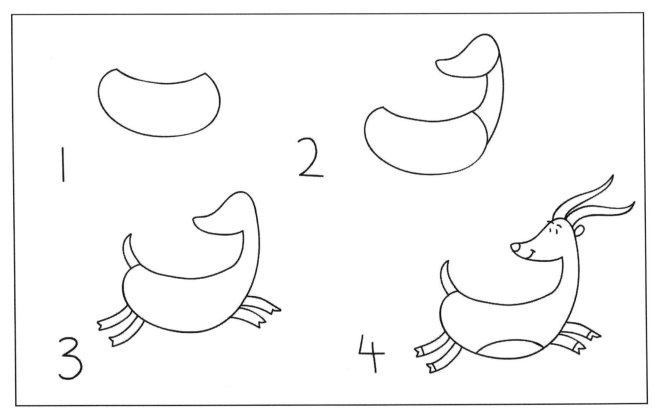

1 2 3 4

YOUR TURN !!

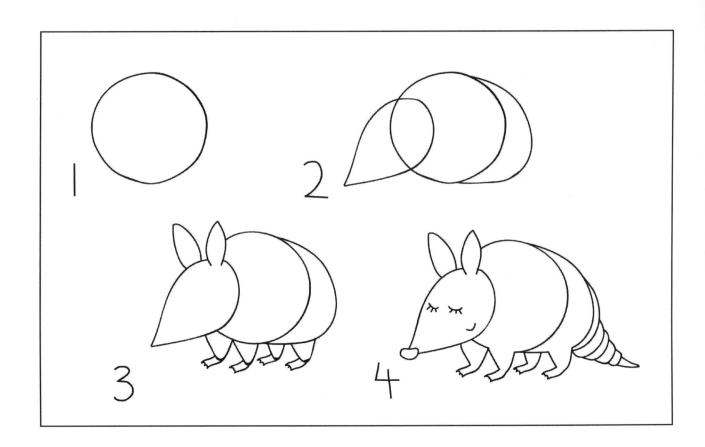

1 2 3 4

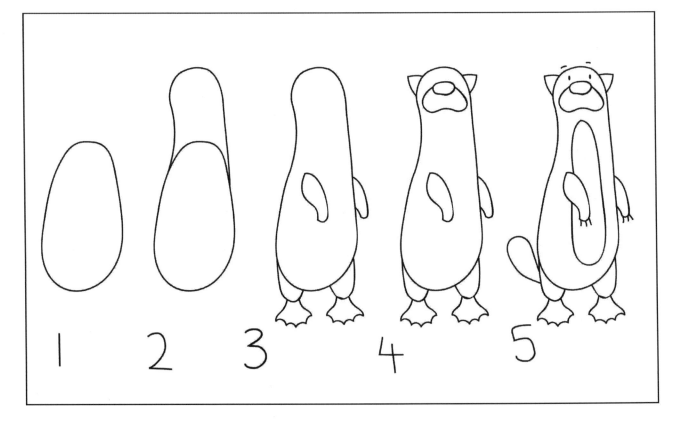

1 2 3 4 5

YOUR TURN !!

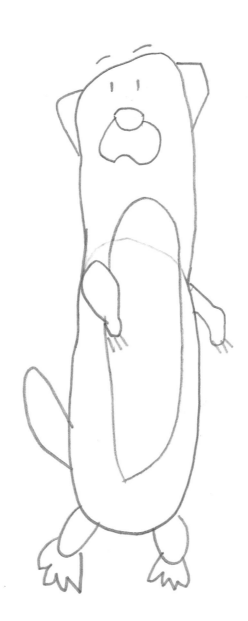

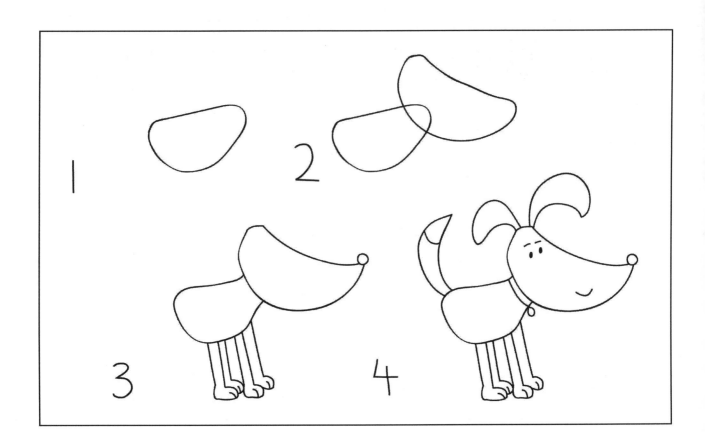

1

2

3

4

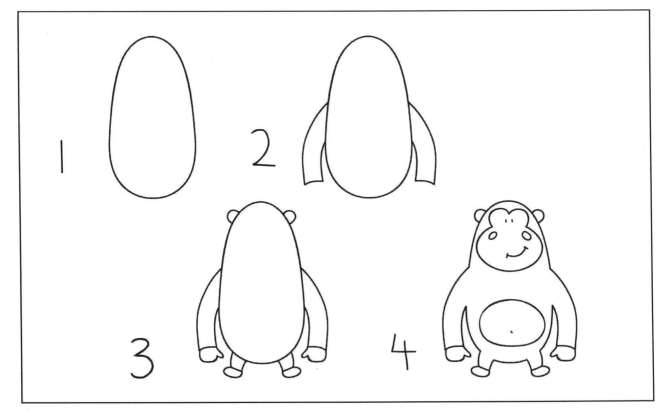

1

2

3

4

YOUR TURN !!

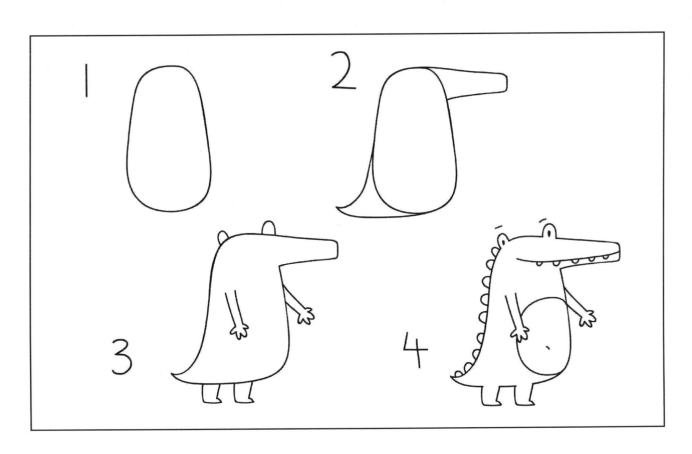

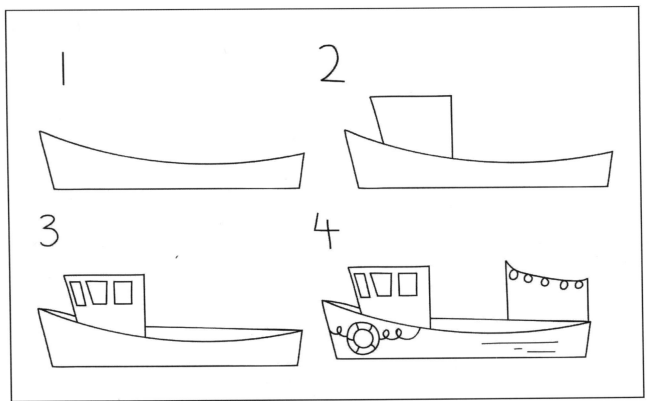

YOUR TURN !!

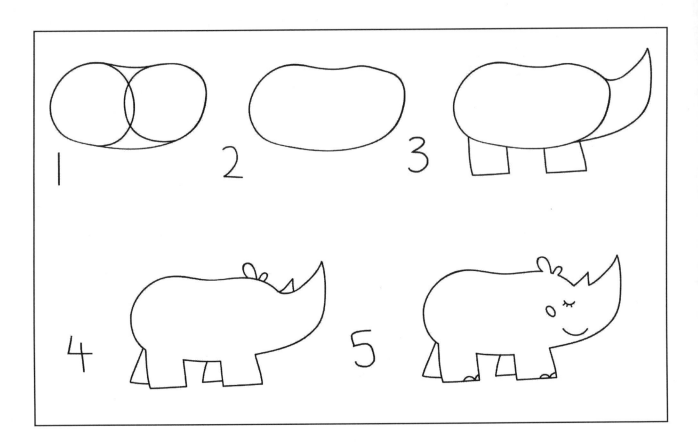

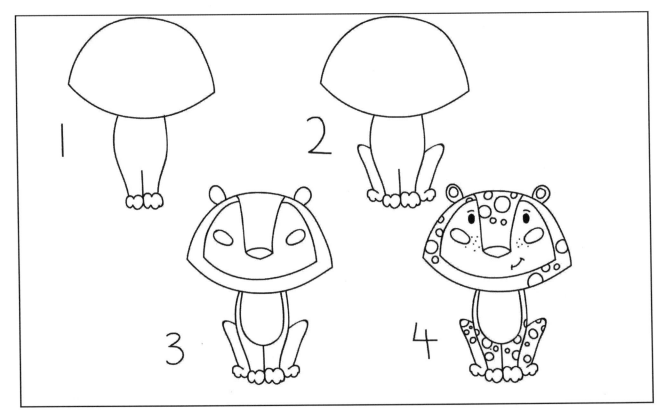

YOUR TURN !!

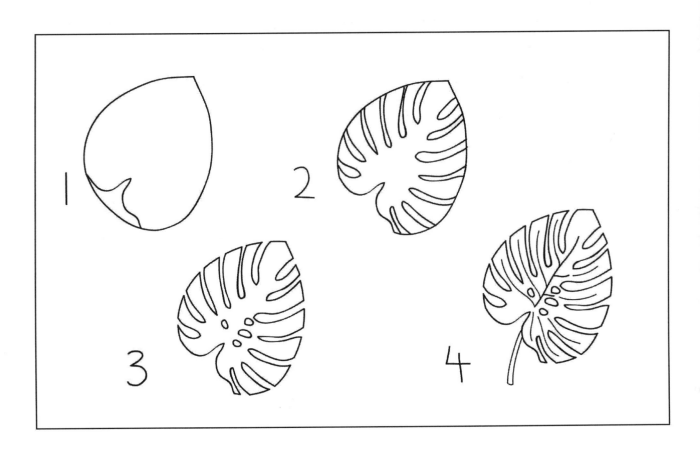

1 2

3 4

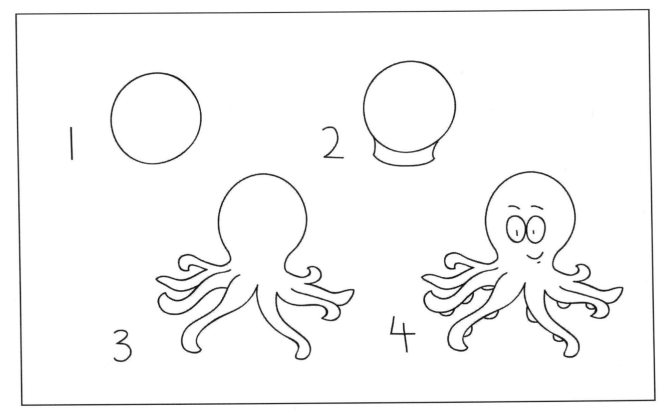

1 2

3 4

YOUR TURN !!

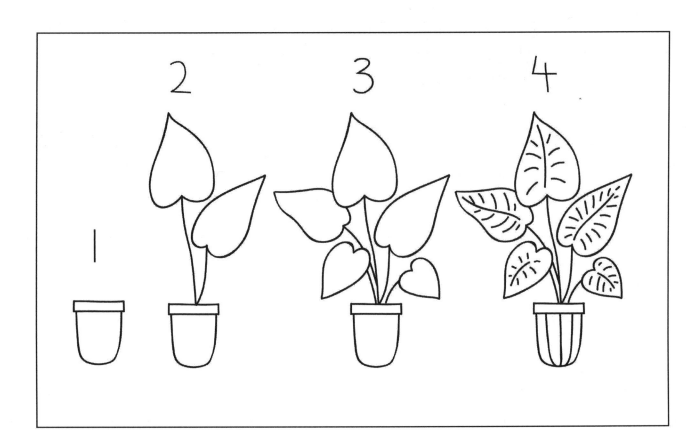

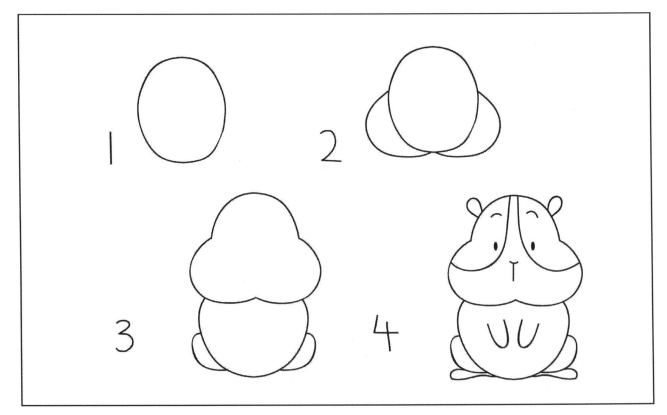

YOUR TURN !!

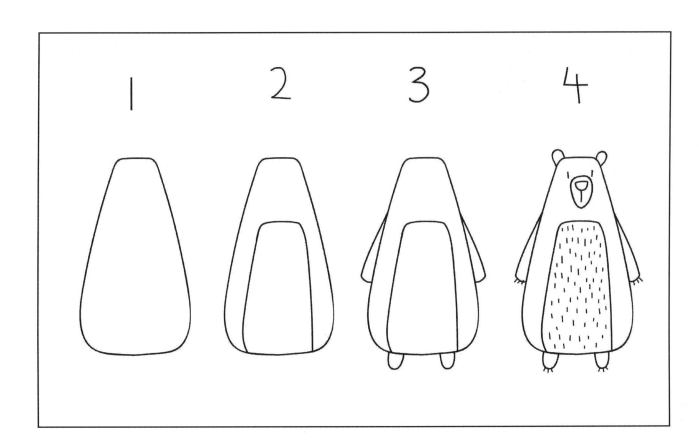

1 2 3 4

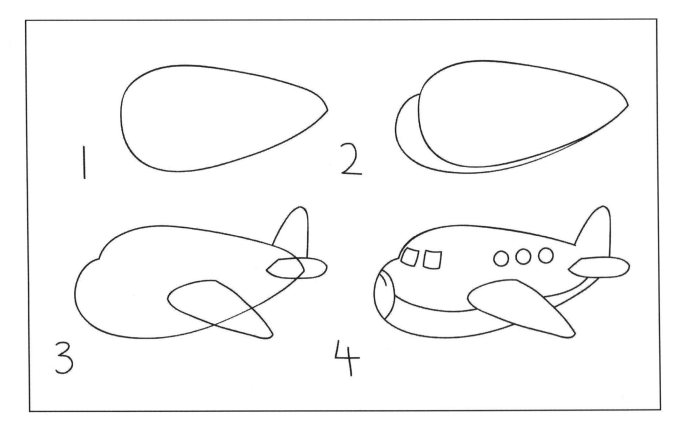

1 2

3 4

YOUR TURN !!

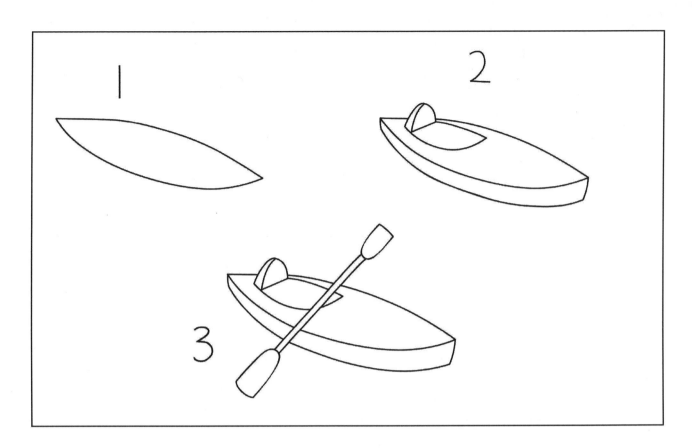

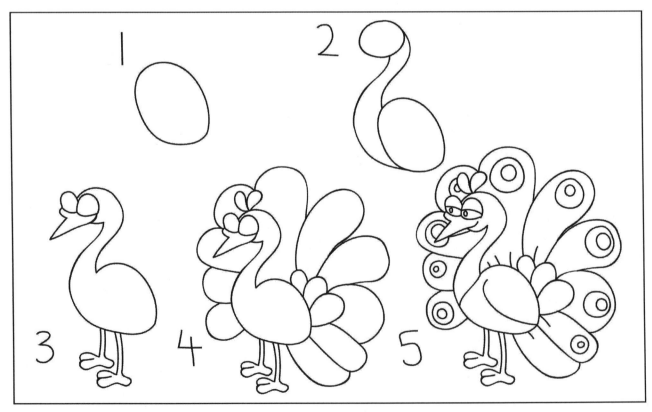

YOUR TURN !!

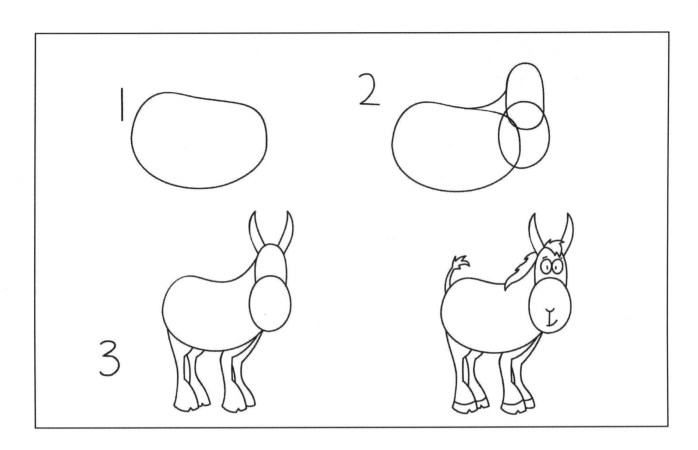

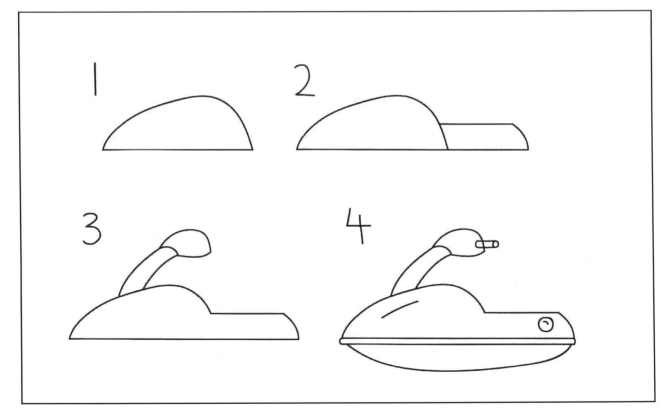

YOUR TURN !!

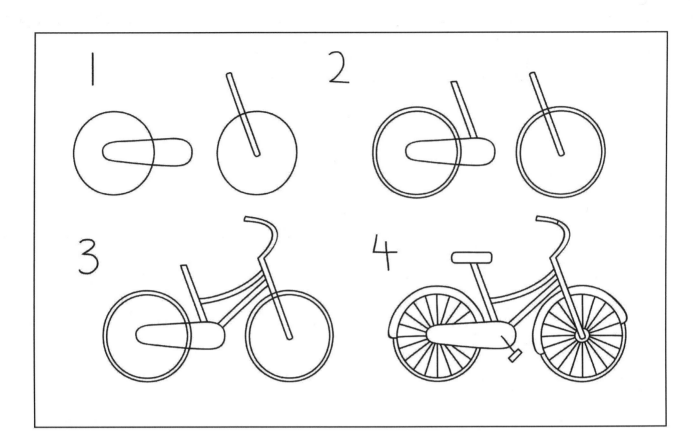

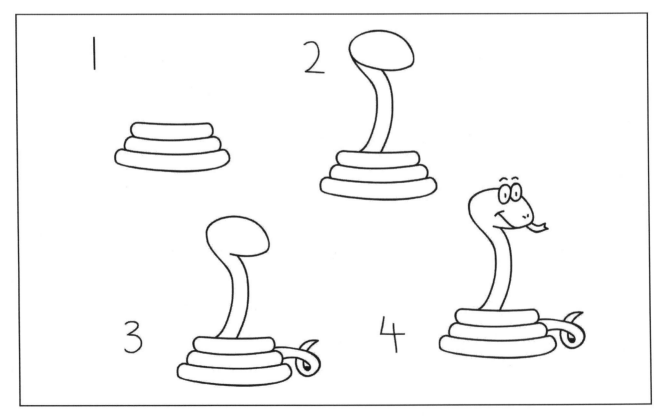

YOUR TURN !!

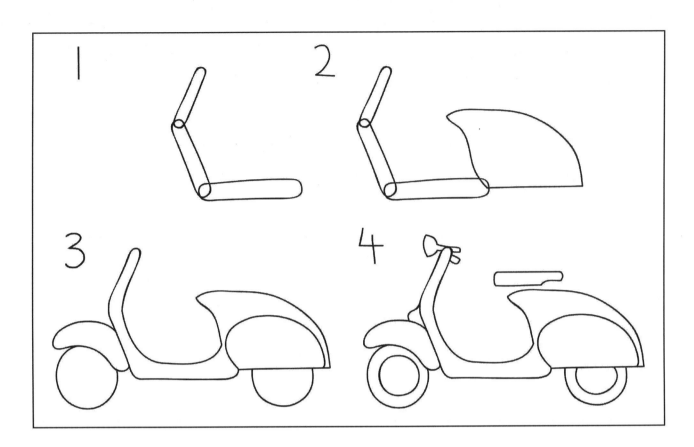

1

2

3

4

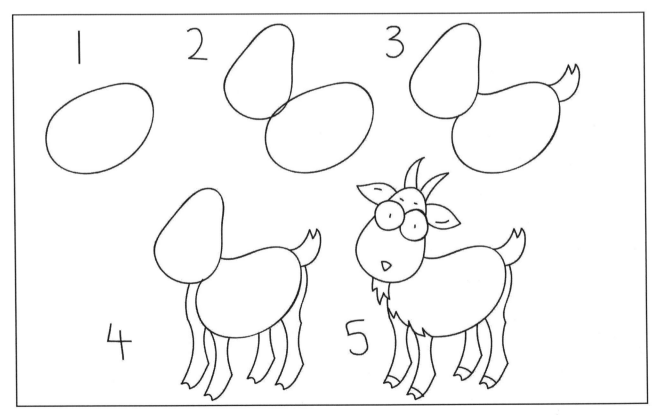

1

2

3

4

5

YOUR TURN !!

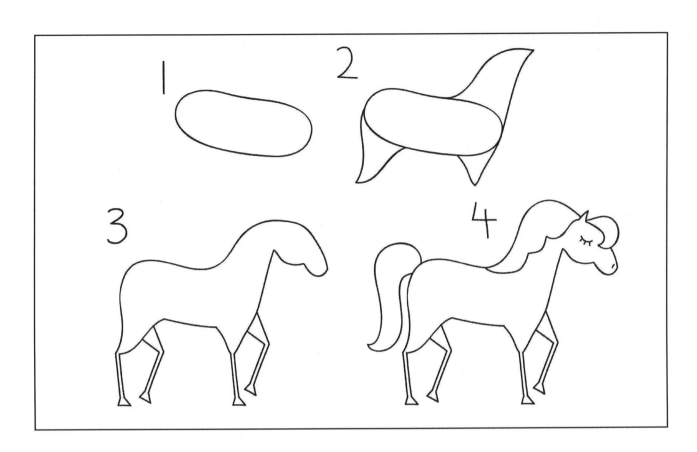

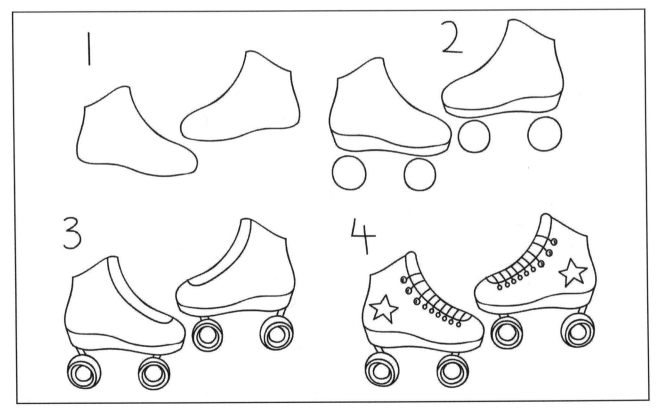

YOUR TURN !!

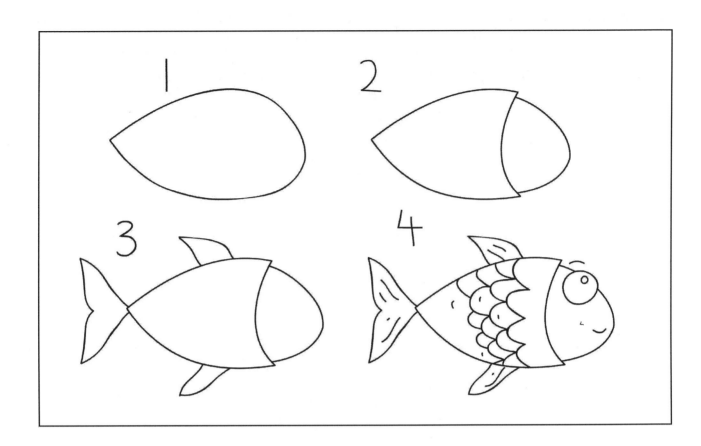

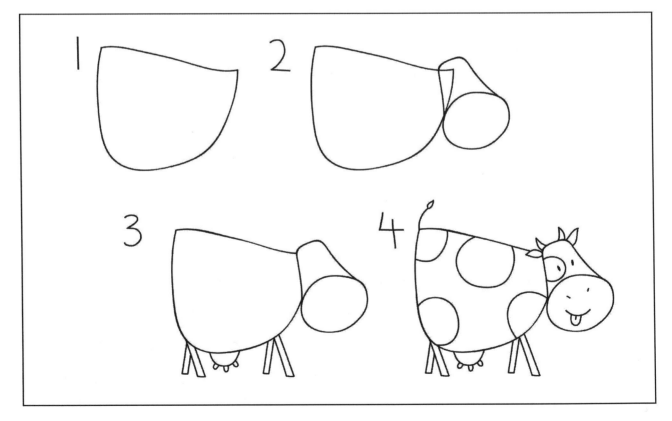

YOUR TURN !!

Made in the USA
Columbia, SC
11 November 2021